D1264985

PERSPECTIVE DRAWING

MARK WAY

NIPPAN
PUBLICATIONS

ON THE
·S·P·O·T·
GUIDES

A Nippan Publications Book

For more information regarding quantity purchases,
please contact:
Director of Marketing, Nippan Publications
1123 Dominguez Street, Carson, California 90746
Phone: (310) 604-9701

© Outline Press Limited 1989
First published in Great Britain in 1989 by
Outline Press Limited

ISBN:1-56970-504-6

All rights reserved. No part of this publication
may be reproduced, stored in a retrieval system,
or transmitted, in any form or by any means or
altered or translated without the prior permission
in writing of the publisher, nor be otherwise
circulated in any form of binding or cover other
than that in which it is published and without a
similar condition being imposed on the
subsequent purchaser.

Printed and Bound in Hong Kong

·C·O·N·T·E·N·T·S·

BASIC PRINCIPLES

As an introduction to perspective drawing, this chapter explains the basic concepts you need to know and the terms used to describe them

THE HORIZON LINE

The horizon line is the junction between sea and sky, appearing as a straight horizontal line. When you look out to sea, the horizon line is obvious in the distance. When your view is across land there is also a horizon line, at sea level, but it may may not be directly visible as the actual level of the horizon may be hidden by hills or buildings.

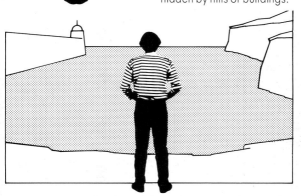

Sometimes the horizon line is only partly visible, as in this illustration, where the line at sea level can be taken to continue behind the harbour wall at left and the cliffs on the right.

Viewpoint

In a perspective view, it is important to establish the relationship of the viewer to the horizon line. the line always represents the spectator's eye level in a drawing and its location depends on the assumed viewpoint.

A high viewpoint such as you have when standing on a cliff top looking towards the horizon enables you to see more of the ground plane.

A low viewpoint shows less of the ground plane and the horizon line is lower down in your view.

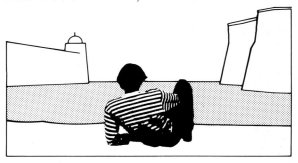

THE PICTURE PLANE

To make a perspective rendering, you imagine a picture plane which corresponds to the flat surface on which you make the drawing. The picture plane cā̄ be illustrated as a sheet of glass positioned between you (the spectator) and the view you are looking at.

These elements are fundamental to your organization of a perspective rendering, whether the subject of your drawing is a landscape or townscape view, an interior, a single object or a group of objects. The relative positions of the spectator, the horizon line and the picture plane govern the construction of the perspective drawing.

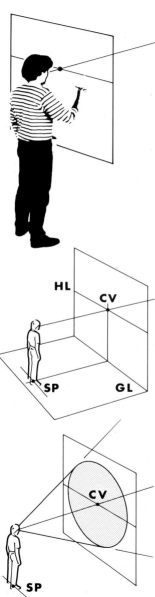

PERSPECTIVE TERMS

Line of sight
An imaginary line travelling from the eye of the spectator to infinity.

Horizon line
A line drawn horizontally across the picture plane at the point of intersection with the line of sight.

Centre of vision
The point of intersection on the picture plane of the line of sight and the horizon line.

Station point
The point on the ground plane where the spectator is standing.

Picture plane
A vertical plane that can be imagined as a sheet of glass in front of the spectator through which the object (the subject of the perspective drawing) is viewed.

Ground line
A horizontal line representing the intersection of the picture plane and the ground plane.

Ground plane
The horizontal plane (the ground) on which the spectator is standing.

Cone of vision
It is usual to limit the area surrounding the line of sight to a range that the eye can cover in comfort. Within this range, objects can be seen in focus and without apparent distortion. This is usually represented as a cone of vision giving a maximum cover of 60°, 30° on either side of the line of sight.

Foreshortening

As in a perspective view, objects receding into the distance appear to get smaller, so equal measurements or units along a receding line appear to get smaller (foreshorten) the farther away they are. If the amount of perspective is slight, the rate of foreshortening is gradual; with severe perspective, the foreshortening is dramatic, with the units becoming smaller more quickly.

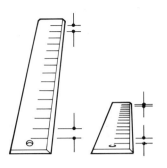

Position of the spectator

By changing the position of the spectator, the view of the object is necessarily changed. The closer you stand, the more foreshortening appears in the image of the object projected on the picture plane, but the size of the object is not dramatically altered.

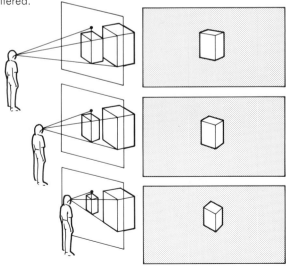

Position of the picture plane

If the object and spectator remain in fixed positions and the location of the picture plane is moved, then the size of the image

on the picture plane can be varied considerably. If the picture plane is close to the object, the size of the image is only slightly reduced from the size of the object. If the picture plane is a long way from the object - that is, close to the spectator - then the image of the object on the picture plane appears small.

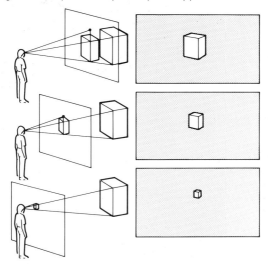

THE PRINCIPLE OF CONVERGENCE

When objects with parallel sides are seen in perspective, parallel lines receding from the spectator appear to converge at the horizon line. If they recede at right angles to the spectator, the lines converge at the centre of vision. These are termed vanishing lines, and the point of convergence is known as the vanishing point.

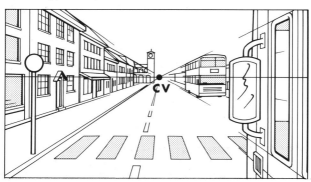

ONE-POINT PERSPECTIVE

Step-by-step constructions
explain how to use
this simple system to
achieve three-dimensional
renderings of individual
objects, interior spaces
and aerial views.

CALL #

TITLE: Perspective Drawing

AUTHOR (LAST NAME, FIRST NAME)
Way, Mark

PUBLISHER & PLACE: Nippan Publications
Carson, California

COPYRIGHT DATE: 1989 EDITION: SERIES:

ISBN #: 1-56970-504-6

DONATED BY: Hadeed - Gift DATE: Nov 2019

NOTES:

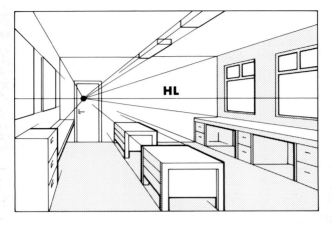

One-point perspective is the simplest form of drawn perspective in that all parallel lines receding directly from you converge at one vanishing point, the centre of vision. Other lines and planes that are square on, or parallel to, the picture plane (and to the spectator) remain parallel and in their true shape, with no distortion or foreshortening.

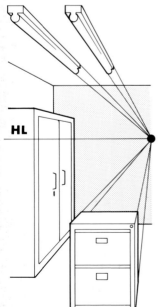

Above the horizon line

For those objects that are above your eye level - that is, above the horizon line - the vanishing lines travel downwards to the centre of vision.

Above and below the horizon line

Some objects may be standing on the ground plane, yet rise to a height above the level of the horizon line. These are said to be above and below the horizon line.

Below the horizon line

For objects that are on the ground plane and fall below the level of the horizon line, the vanishing lines appear to rise to the centre of vision.

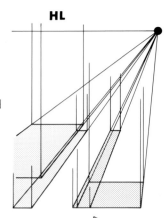

The image can be broken down to a few simple construction lines. It is often convenient to construct the outline of an object on the ground plane, then to project vertically from this outline and construct the height of the object on the vertical lines. This method applies equally to objects which do not sit on the ground plane as the plan view is the same although the base height is above ground level.

YOUR PAPER AS THE PICTURE PLANE

When first setting up a perspective construction, you need to imagine the picture plane and ground plane with the spectator standing at a given point. From this position, you can locate the horizon line and ground line.

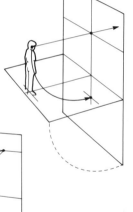

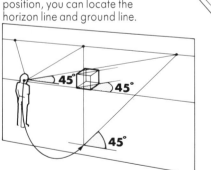

Then imagine the ground plane folded back flat as a continuation of the picture plane. This enables you to plot the position of the station point.

Imagine a cube sitting on the ground plane behind the picture plane, with the front face parallel to and touching the picture plane. If a diagonal is drawn from one corner of the cube, it recedes at 45° to the picture plane. This 45° angle can be plotted from the eye of the spectator and projected until it meets the horizon line.

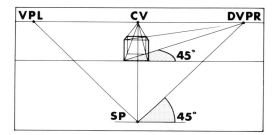

When this is constructed as a flat plan on a sheet of paper, the horizon line and ground line are drawn horizontally and the position of the spectator drawn on a vertical line travelling downward from the centre of vision. The 45° vanishing line is drawn from this station point.

The point where this vanishing line meets the horizon line is called the diagonal vanishing point (DVP), whether to right or left of the centre of vision.

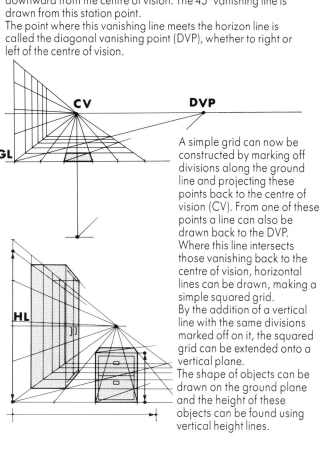

A simple grid can now be constructed by marking off divisions along the ground line and projecting these points back to the centre of vision (CV). From one of these points a line can also be drawn back to the DVP. Where this line intersects those vanishing back to the centre of vision, horizontal lines can be drawn, making a simple squared grid.

By the addition of a vertical line with the same divisions marked off on it, the squared grid can be extended onto a vertical plane.

The shape of objects can be drawn on the ground plane and the height of these objects can be found using vertical height lines.

CONSTRUCTING A ONE-POINT PERSPECTIVE GRID

Set the horizon line on the sheet of paper.
Draw in a rectangle and mark points around it evenly spaced at a convenient measure.

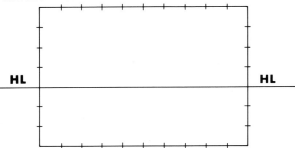

Draw lines from the points on the bottom edge of the rectangle back to the centre of vision, allowing the lines to extend forward from the rectangle.

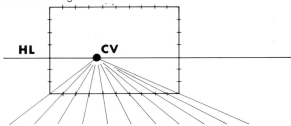

Locate the diagonal vanishing point to one side of the rectangle. The closer the DVP to the rectangle, the more acute the foreshortening will appear.
Draw a line from the lower lefthand corner of the rectangle to the DVP. Where it cuts the lines vanishing back to the centre of vision, draw horizontal lines to construct a squared grid on the ground plane.

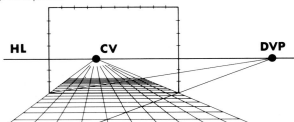

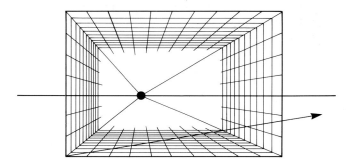

Project the points on the other sides of the rectangle back to the centre of vision. Then project points from the squared grid on the ground plane up the vertical sides and across the top to form the complete squared-up one-point perspective grid.

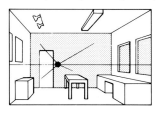

Interior views

These simple one-point grids can be used to real effect in interior views, the basic grid representing the floor, walls and ceiling of a room. Objects within the room can be drawn in relation to the grid to construct a realistic view.

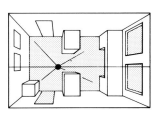

Aerial views

Aerial views are easily produced simply by drawing a plan of the room interior and projecting the object out towards you. These views give a very clear impression of the layout and spatial relationships within the design.

Bird's eye views

Larger scale views are also possible, showing buildings and intersecting streets, for example. This combines an accurate impression of the layout with a feeling of height and relative scale.

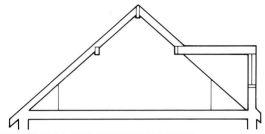

SECTIONAL PERSPECTIVE VIEW
Diagonal measuring line on the ground plane

A simple interior perspective rendering can be constructed using the sectional elevation of the room as the basis of your drawing.

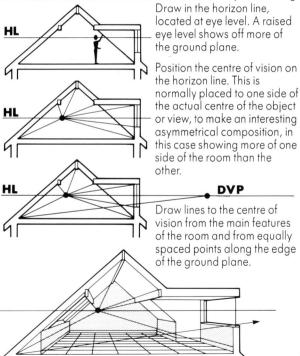

Draw in the horizon line, located at eye level. A raised eye level shows off more of the ground plane.

Position the centre of vision on the horizon line. This is normally placed to one side of the actual centre of the object or view, to make an interesting asymmetrical composition, in this case showing more of one side of the room than the other.

HL

HL

HL **DVP**

Draw lines to the centre of vision from the main features of the room and from equally spaced points along the edge of the ground plane.

Position the diagonal vanishing point at one side of the elevation. The distance of the DVP from the centre of vision should be at least equal to the width of the section to be drawn. Add a diagonal vanishing line to construct a squared grid on the ground plane.

Using the diminishing squares as a measure, you can plot distances back into the room and points projected around the room to build up the complete view.

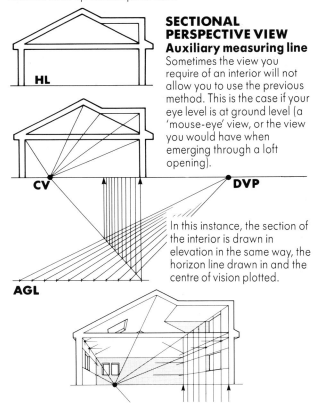

SECTIONAL PERSPECTIVE VIEW
Auxiliary measuring line

Sometimes the view you require of an interior will not allow you to use the previous method. This is the case if your eye level is at ground level (a 'mouse-eye' view, or the view you would have when emerging through a loft opening).

In this instance, the section of the interior is drawn in elevation in the same way, the horizon line drawn in and the centre of vision plotted.

An auxiliary ground line or measuring line is added below the section at any convenient distance (it could also be placed above).

Mark off the divisions along the auxiliary line and project lines back to a diagonal vanishing point on the horizon line.

Take a vanishing line back to the centre of vision to cross all these diagonal vanishing lines. Where they cross, project the points vertically into the room interior.

These lines now represent the squared grid divisions running back along the inside of the wall. Features can be plotted using these divisions and projected around walls and ceiling to complete the perspective.

ONE-POINT PERSPECTIVE CUBE

Set up a horizon line, station point and centre of vision. The diagonal vanishing points can be found the same distance along the horizon line as the station point is from the centre of vision. These points are sometimes also referred to as the measuring points centre of vision (MPCV).

Draw a square on the picture plane and project lines back from each corner to the centre of vision.

Take lines from the bottom two corners back to the diagonal vanishing points. Where they cross the lines going back to the centre of vision, the back edge of the cube is found.

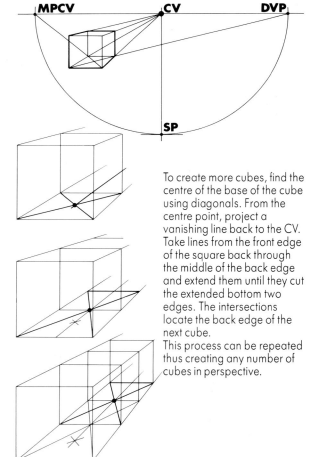

To create more cubes, find the centre of the base of the cube using diagonals. From the centre point, project a vanishing line back to the CV. Take lines from the front edge of the square back through the middle of the back edge and extend them until they cut the extended bottom two edges. The intersections locate the back edge of the next cube.

This process can be repeated thus creating any number of cubes in perspective.

Extending from a vertical plane

When the cube lies on or near the horizon line, with little of the ground plane visible, it is difficult to draw the diagonals accurately enough to create new cubes. In this instance the station point becomes the diagonal vanishing point for the square on the vertical plane.

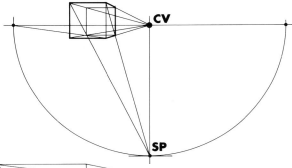

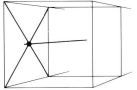

Find the centre of one of the vertical planes of the cube. Project a vanishing line back from this to find the mid point of the line at the back of the cube.

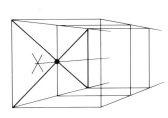

Extend the vanishing lines at top and bottom of the vertical plane back towards the centre of vision. From the two front corners of that vertical plane, project lines through the mid point on the back line to intersect the extended side edges of that square. The intersections locate the back edge of the next cube.

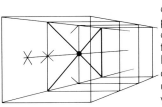

This can be repeated to create a line of cubes diminishing in perspective. The cubes can also be extended forward of the original one.
In this way you can build up a cube grid which could be used to construct an object within.

GRID CONSTRUCTION
Enlarging a cube

You can construct an elaborate one-point perspective grid from an accurately constructed cube. The grid can be used as the basis of a perspective rendering of any object which can be fitted within the cube. The first stage is to enlarge a perspective cube to a size suitable for the grid.

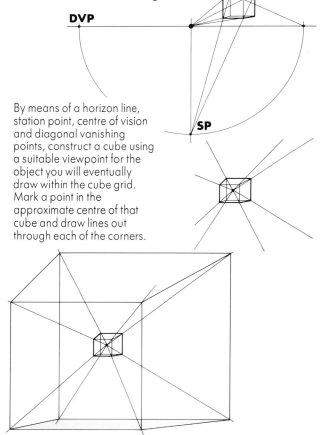

By means of a horizon line, station point, centre of vision and diagonal vanishing points, construct a cube using a suitable viewpoint for the object you will eventually draw within the cube grid. Mark a point in the approximate centre of that cube and draw lines out through each of the corners.

At a distance from the original cube, start by drawing one line parallel to a line on the cube.

Then draw another line parallel to another line of the cube from one of the end points of your first line.

Continue with this process and you will be able to draw a much larger cube which has the same angles and proportions as the original one.

Subdividing with diagonals

External surface By means of diagonals, you can subdivide the front face of the cube into quarters, eighths and so on, joining up the diagonals with vertical and horizontal lines. The side face of the cube can be subdivided in the same way, with verticals passing through the diagonals in one direction and vanishing lines in the other direction. You will have to use some care in estimating the correct vanishing points for these lines.

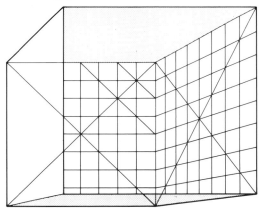

Internal surface The same process can be used to divide up the internal faces of the cube. This will give you a regular grid and a means of constructing an object within this framework. Intermediate measurements can be made by marking along a vertical or horizontal line and projecting onto a main diagonal of one of the faces to give the correct effect of foreshortening.

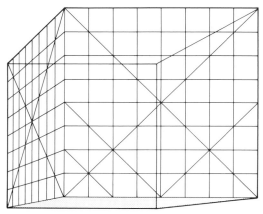

CIRCLES IN PERSPECTIVE

When a circle is viewed square on (or perpendicular to the line of sight) the image we see is a true circle.

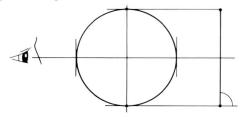

When that circle is inclined at an angle, say 60°, one axis is foreshortened and we see an ellipse. We call this a 60° ellipse ratio.

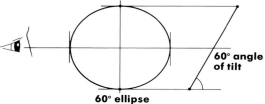

60° angle of tilt

60° ellipse

An ellipse is the image that appears when a circle is seen at any angle other than square on. The greater the angle, the more foreshortening on one axis and the narrower the ellipse appears.

Ellipse drawing guides or templates are stepped in convenient angle changes. They can range from 80° (nearly a circle) through 5° changes down to as little as 10° or 5° which are very thin ellipse shapes.

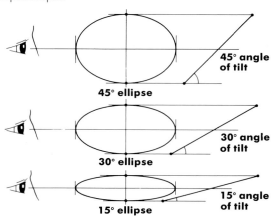

45° angle of tilt

45° ellipse

30° angle of tilt

30° ellipse

15° angle of tilt

15° ellipse

There are two main axes on an ellipse. The major axis is the longest measurement, equal to the diameter of the circle that the ellipse is derived from. The minor axis is at right angles to the major axis and is the shortest measurement on the ellipse. This indicates the greatest amount of foreshortening from the circle.

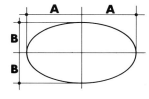

When drawing a circle in perspective it must be remembered that the perspective centre of the circle will not be the same as the geometric centre of the ellipse.

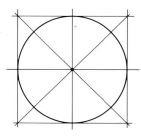

If you draw a square around a circle and draw that square in perspective, you can then draw a perfect ellipse to fit inside it. The centre of that ellipse will be halfway between the front and back lines of the square and halfway in from each side. But the perspective centre of the circle will be where the diagonals of the perspective square meet. Each new ellipse drawn should be constructed within a square to suit its size.

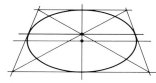

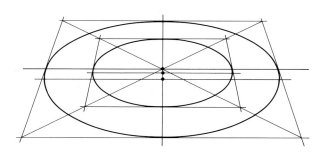

Constructing with circles

When drawing circles in a one-point perspective construction, if they are square on, or perpendicular to, the line of sight, then they are seen as circles.

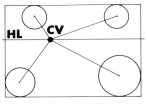

In this instance the circles of various sizes are drawn on the picture plane and vanishing lines are projected back to the centre of vision.

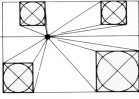

Squares are drawn around these circles and vanishing lines drawn back from the corners of these squares to the centre of vision.

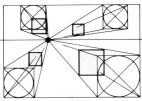

Smaller squares can now be drawn into the picture which can be used to locate the positions of more distant circles within the perspective view.

When circles are drawn in those squares the construction can be seen as representing the ends of cylinders of various lengths. By joining the ends of the major axes between pairs of ellipses, the cylindrical forms are completed.

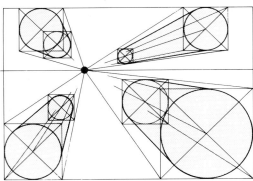

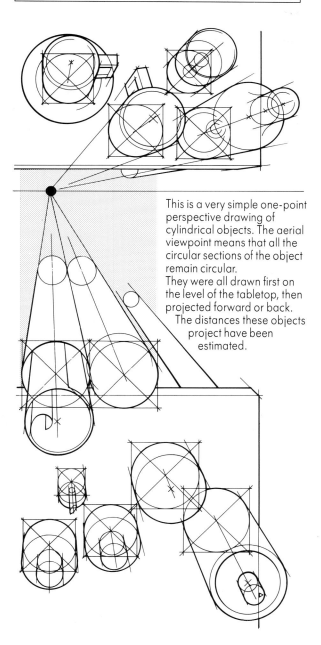

This is a very simple one-point perspective drawing of cylindrical objects. The aerial viewpoint means that all the circular sections of the object remain circular.

They were all drawn first on the level of the tabletop, then projected forward or back.

The distances these objects project have been estimated.

Horizontal ellipse construction

When the circles in a one-point perspective construction are on the horizontal planes, they will appear as ellipses.

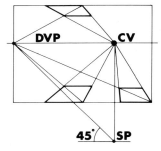

In this instance the sizes of the circles (diameter length) are plotted on the picture plane as horizontal lines, and vanishing points are taken back to the centre of vision. A diagonal vanishing point is added and the diagonals drawn in to create perspective squares.

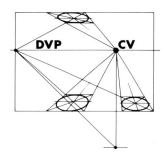

Ellipses can now be drawn within these squares. The ellipse ratios vary according to the distance above or below the horizon line.

Using vanishing lines from the original square and diagonal vanishing lines, additional ellipses can be constructed which diminish in size with the perspective. This diminishment may apply to both the ellipse ratio and the length of the major axis, depending on the position in relation to the horizon line.

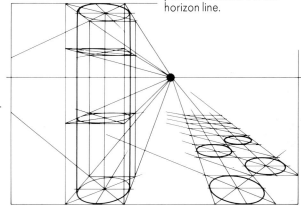

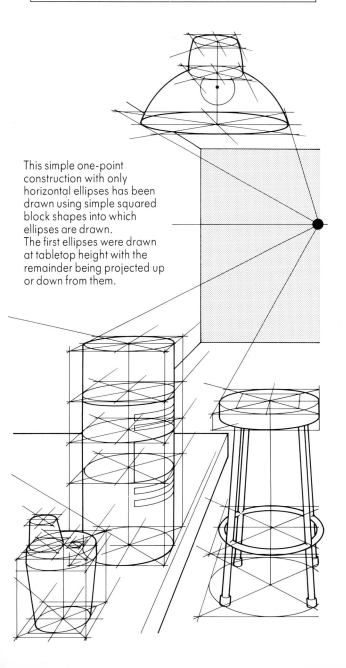

This simple one-point construction with only horizontal ellipses has been drawn using simple squared block shapes into which ellipses are drawn.
The first ellipses were drawn at tabletop height with the remainder being projected up or down from them.

Vertical ellipse construction

For circles drawn on receding vertical planes in one-point perspective, the station point is used as the diagonal vanishing point.

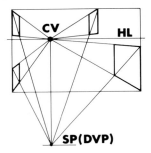

The sizes of the circles (diameter length) are plotted on the picture plane as vertical lines, and vanishing lines are taken back to the centre of vision.

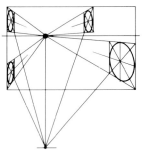

Vanishing lines are also drawn from one end of each vertical line back to the diagonal vanishing point (station point). These create perspective squares into which ellipses can be drawn.

Any additional squares and ellipses can be constructed in the same way. The major axis of the ellipse should be a vertical line, but distortion does occur as the view moves out of the range of the cone of vision.

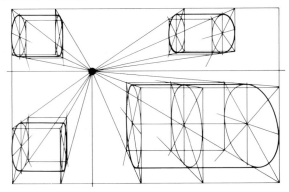

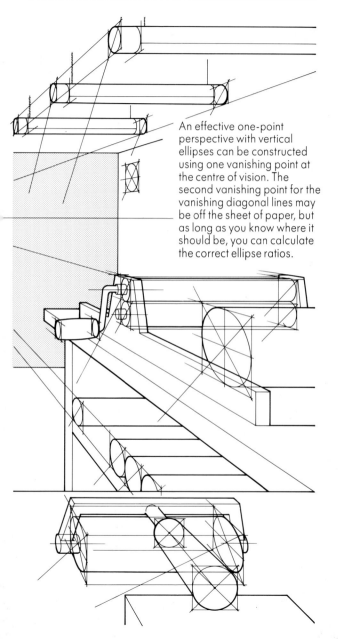

An effective one-point perspective with vertical ellipses can be constructed using one vanishing point at the centre of vision. The second vanishing point for the vanishing diagonal lines may be off the sheet of paper, but as long as you know where it should be, you can calculate the correct ellipse ratios.

TWO-POINT PERSPECTIVE

This method equips you with a more complex approach to viewpoints and angles in three dimensions, increasing the realism of your perspective drawing.

In two-point or angular perspective, the parallel sides of shapes are revolved at various angles to the picture plane. With objects of regular shape, there are two vanishing points on the horizon line.

When constructing objects or a grid in two-point perspective, it is usual to work with lines or planes that are at right angles to each other, such as the corners or faces of a cube. The three dice are used as an example.

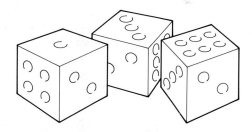

When the objects are seen in plan view, the angles they make with the picture plane can be shown. These angles can be plotted from the station point to locate the various vanishing points on the horizon line.

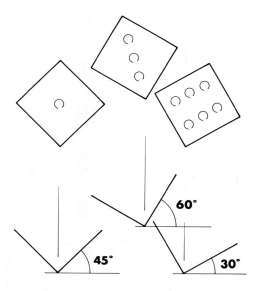

The three constructions here show the vanishing points relating to the 45°/45°, 60°/30° right and 60°/30° left angles of the dice. These vanishing points should be plotted clearly and marked on the horizon line.

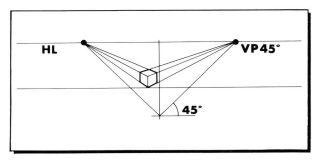

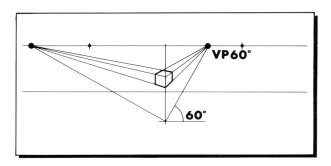

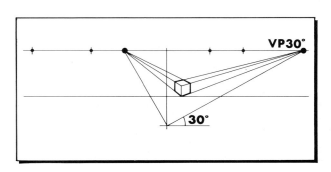

Height lines

Height lines are used to measure the height of a line which occurs where an object touches the picture plane. These are also used to measure heights of lines behind the picture plane or within the image.

A height line is drawn vertically from the ground line and measurements are made up this vertical line.

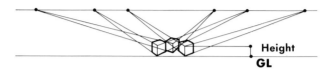

Height lines can be drawn at any position on the ground line, but it is often convenient to place them where lines of an object touch or are projected onto the picture plane.

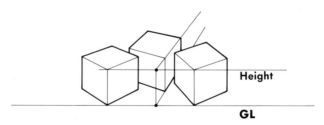

All sides of equal height can be measured at the picture plane and projected back to any point on the horizon line.

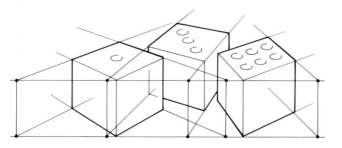

A single object in two-point perspective

To construct a simple two-point perspective of an object, you have first to establish the angles that the object makes with the picture plane.

These become clear when the object is seen in the plan view and the angles can be drawn in.

The picture plane and spectator can also be drawn and lines of sight projected back from points on the object to intersect the picture plane. These are the measuring points.

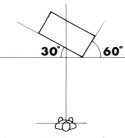

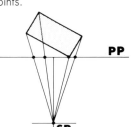

When seen in diagram form, with the spectator standing in front of the picture plane, the front edge of the object is touching the picture plane at a point known as point A.

Lines are drawn from the eye of the spectator parallel to the sides of the object to join the horizon line at the two vanishing points, right and left.

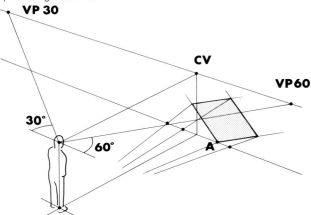

With the horizon line, ground line, station point and vanishing points plotted, you can start to construct the object. Place the front corner of the object (point A) on the ground line. Draw the other measuring points on the ground line.

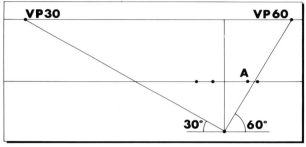

Draw vertical lines from each of the measuring points. The vertical line at point A can be used as a height line and the height of the object marked on it. From this height mark, draw vanishing lines to the two vanishing points.

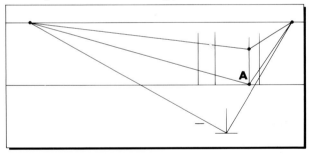

The intersection points where the vertical measuring lines cross the vanishing lines mark the various points necessary for drawing the whole shape of the object.

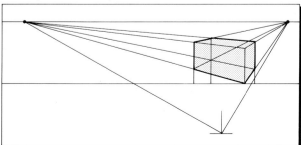

Grouped objects in perspective

In this exercise, three objects are to be drawn in two-point perspective: a desk tidy, drawing board and filing cabinet. The plan view shows the relationship of the three objects.

Draw a simple plan view showing the objects in their correct relation to the picture plane. This shows point A, where the first object touches the picture plane.
Locate the station point and check that all the objects appear within the cone of vision, that is, 30° either side of the line of sight.

Project lines (visual rays) back from the corners of the objects onto the picture plane and mark these measuring points on a sheet of paper.

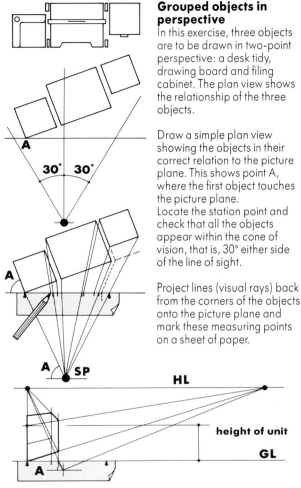

To plot the perspective view, first draw the horizon line, ground line and vanishing points. Locate point A at the correct distance to one side. Draw a vertical line from this point to form the height line.
Mark the measuring points for the first object on the ground line and project verticals upwards. Draw vanishing lines from the height line back to the right vanishing point. Where these lines cross the vertical lines, you find the points required to draw the shape of the first object.

Repeat this process for the second and third objects, using the measurement points previously marked on your sheet of paper and transferring them to the ground line. Draw verticals from these. The height of each object is added to the height line, but a

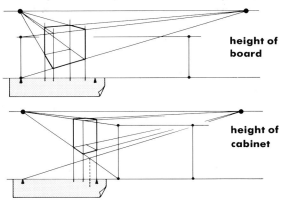

height of board

height of cabinet

new height line (the dotted line) has been introduced for the filing cabinet, as it sits back from the front edge of the other shapes.

In each case the outline of the object is constructed on the ground plane and the height determined by means of a height line on the picture plane. This is the only place where true scale measurements can be made.

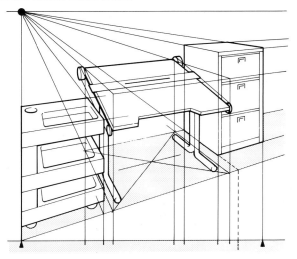

Additional vanishing points

In most cases the vanishing points are at right angles to each other when seen in the plan view, but there are often exceptions to this. Doors ajar, walls at odd angles, roads running off at different directions; each will require its own vanishing point which will still be on the horizon line.

With planes that are inclined or tilted in relation to the horizontal, the sides do not vanish to points on the horizon line but to points vertically above or below what would be the vanishing point on the horizon line if the planes were lying flat.

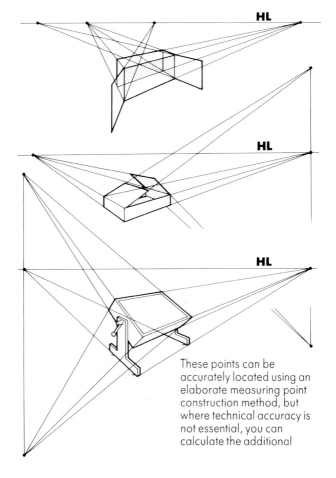

These points can be accurately located using an elaborate measuring point construction method, but where technical accuracy is not essential, you can calculate the additional

vanishing points by eye. The examples shown here simply demonstrate the principle that the vanishing points for these inclined planes lie vertically above or below the appropriate horizontal vanishing point.

When constructing something such as a house with inclined roof planes, it is important to to be aware of the vanishing points for the sides of the roof. These help to give a correct sense of the perspective, although the shape of the roof can be constructed without them.

HL

The pages of a book create an elliptical shape as they are turned over because the planes are of equal length. Their sides vanish to points above or below the horizon line. This principle applies to other similarly constructed objects.

HL

Although these constructions show the use of more than two vanishing points, they are still termed two-point perspective. This is because the basic object has only two of its principal planes inclined to the picture plane, the third plane being parallel to the ground.

ARCHITECTURAL RENDERING

One common use of two-point perspective is in interpreting architects' drawings into artists' impressions showing a realistic perspective. These can be simple to construct in that accurate plans and elevations are normally drawn by the architect to a convenient scale.

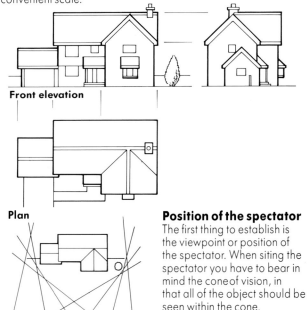

Front elevation

Plan

Position of the spectator

The first thing to establish is the viewpoint or position of the spectator. When siting the spectator you have to bear in mind the cone of vision, in that all of the object should be seen within the cone.

The distance of the spectator from the building is important to give a realistic view, and the normal calculation for this distance is about three times the height of the building.

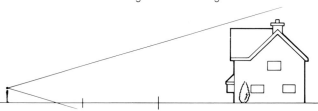

It is important to try a number of viewpoints in order to select the one that shows the building to best advantage. In the first, the gable end wall projects forward and is too dominant. Detail is lost around the front door.

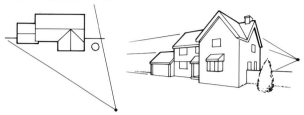

In the second, too much is seen of the end wall with the front elevation being too much foreshortened. This is the correct side from which to view the front entrance door, but the spectator should move a little further around to the front of the house to obtain a more direct view.

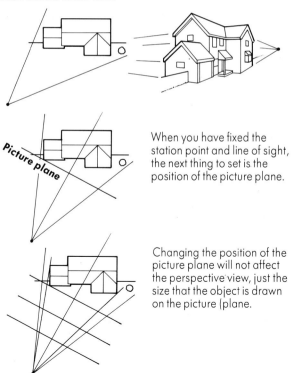

When you have fixed the station point and line of sight, the next thing to set is the position of the picture plane.

Changing the position of the picture plane will not affect the perspective view, just the size that the object is drawn on the picture (plane.

Positioning the picture plane

If the picture plane is placed just in front of the building and lines (visual rays) are drawn from points on the object to the spectator, the points where the lines touch the picture plane indicate the size of the drawing.

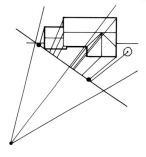

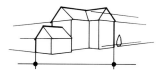

If you require a larger drawing, the picture plane can be moved back into the building. The building then projects in front of and behind the picture plane. Visual rays

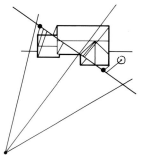

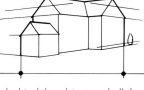

are then projected both forward and back onto the picture plane.

For a larger drawing still, the picture plane can be placed

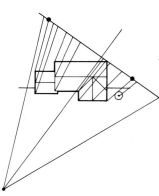

behind the object and all the visual rays drawn back from the spectator through the relevant points onto the picture plane. The one disadvantage with this is that the main construction points, the vanishing points, are so far apart that they do not fit easily onto a large sheet of paper.

Constructing the perspective view

In this example, the picture plane is fixed just in front of the building and the vanishing points can be drawn. To locate these, lines parallel to the walls of the building are drawn from the station point to the picture plane.

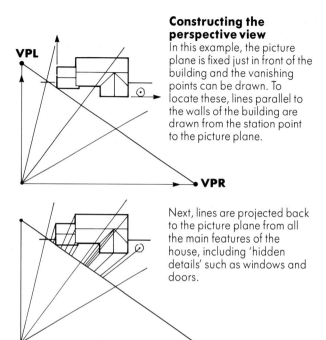

VPL

VPR

Next, lines are projected back to the picture plane from all the main features of the house, including 'hidden details' such as windows and doors.

The positions of the main height lines are also established by extending the lines of the roof ridges until they hit the picture plane. Now you can choose the position of the ground line and horizon line. These can create a wide variety of views, depending on whether you assume yourself to be standing at a low level looking up, or high up looking down.

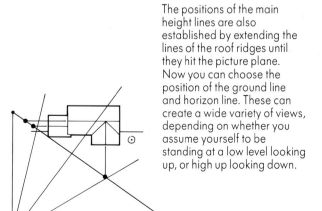

Low viewpoint If the ground plane is above you, the ground line will appear above your eye level, the horizon line. This will give you a view looking up at the building. Some lower detail of the house would be lost behind the ground.

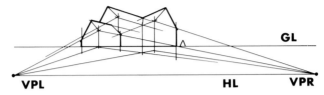

High viewpoint With the ground plane well below you, it would intersect the picture plane low on your sheet of paper to establish a ground line well below the horizon line. This will give an aerial view but one pitfall of this viewpoint is that the building may look like a small-scale model.

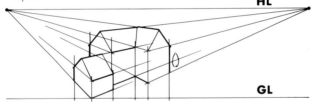

Avoid placing the horizon line where it will coincide with one of the main horizontal lines of the house, as this can create some strange illusions.

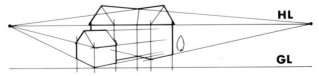

A good solution is to imagine the building standing on level ground, and yourself as spectator standing on that same plane. This provides an eye level at the height of a person, giving a true human scale to the building.

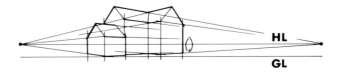

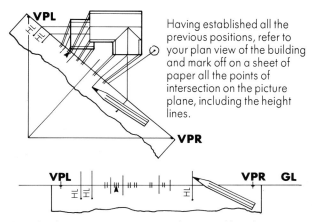

Having established all the previous positions, refer to your plan view of the building and mark off on a sheet of paper all the points of intersection on the picture plane, including the height lines.

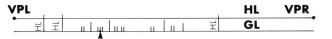

Transfer these measurements onto the ground line drawn on your large sheet of paper. Add the horizon line, vanishing points and centre of vision.

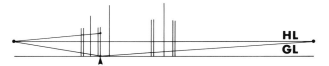

Start the perspective view by drawing vanishing lines from point A (in this instance the nearest point on the building which is touching the picture plane) to the two vanishing points.

Project vertical lines up from the end gable points as marked on the ground line. Draw in the height lines and mark on those the height of the ridges and eaves of the roof. From these height lines take vanishing lines back until they hit the vertical centre of each end gable.

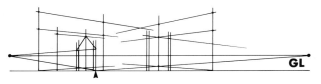

The shape of the end gables can now be drawn from the various intersection points.
Project vanishing lines from the points of the roof to join up and form the overall shapes of the roofs and walls.

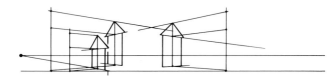

Additional detail such as windows and doors, for which you have measurement points shown on the ground line, can now be constructed. Project vertical lines from these points to appear on the walls of the building. Mark their various heights on the appropriate height lines and by means of vanishing lines, project these heights back onto the centre lines of the end gables. These points can then be drawn around the building until they intersect the correct vertical lines.

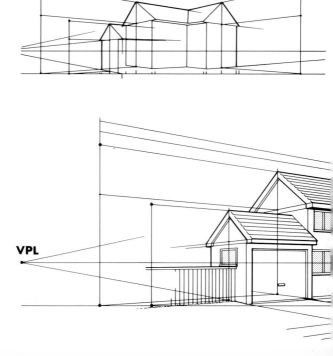

When constructing an architectural view, it is worth taking some care at the initial stage to be as accurate as possible. If the main features are placed very accurately, you can be confident when it comes to filling in detail. This can be done by eye or by comparison of one size to another size.

Remember that the sloping edges of the roofs will vanish to points above or below the horizon line. It is a common fault that the illustrator forgets this, as it is not a vital factor in the construction.
Once the basic framework is drawn out all the necessary detail on the building can be

added. A clear understanding of building construction methods is a great help when completing a drawing like this, and there is no substitute for detail drawing 'on site' to establish the correct architectural detailing and construction features.

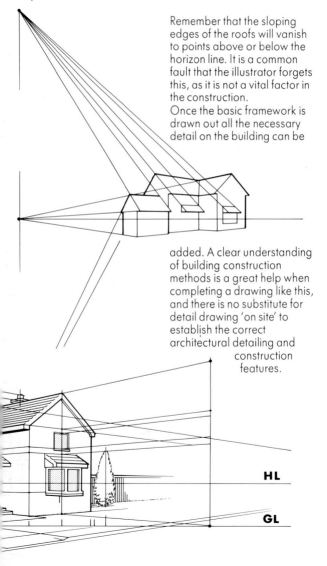

HL

GL

PERSPECTIVE GRIDS

Grid construction
provides a framework
within which you can
accurately plot complex
forms, demonstrated
here with two-point and
three-point perspective
grids.

TWO-POINT PERSPECTIVE GRID

The examples of perspective drawing shown up to now have made direct use of a horizon line with vanishing points to create the perspective. This is often not the best or easiest method. For example, when drawing a single, complex object with a number of components, you will find it easier to plot the whole shape of the object and the relationships of its component parts using a perspective grid. This dispenses with the need to locate the horizon line and vanishing points within the scale of your drawing.

To investigate the principle of constructing a grid, first imagine two vertical planes vanishing to infinity at their respective vanishing points.

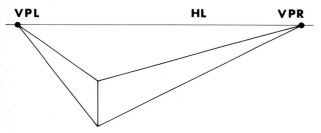

These planes can be cut short by another vertical plane placed closer to the spectator and, in this case, perpendicular to the line of sight.

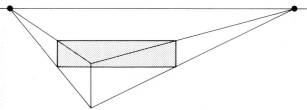

If other sets of vanishing lines are drawn from the original front vertical back to different points on the horizon line, you will observe that they intersect this new vertical cutting plane to give a standard reduced height.

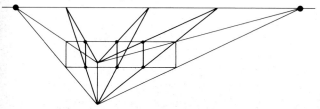

You can now construct a set of perspective lines by drawing a vertical AB and drawing left and right vanishing directions 1 and 2. Add a new vanishing direction 3 to give the perspective effect. Draw in a horizontal reference line (HRL), and drop verticals where this line cuts 1 and 2. Where the vertical cuts 3, draw a second horizontal to give vanishing direction 4.
We know from the original example that if these vanishing lines 1 and 4, 2 and 3 were extended, they would meet on a common horizon line.

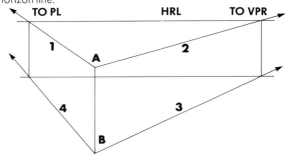

Dividing the grid
To give a simple grid of lines the vertical AB can be divided in half and then quarters, and the verticals at 1/4 and 2/3 can be divided in the same way. Vanishing parallels are made by joining corresponding points on the verticals.

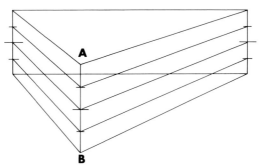

An alternative way to subdivide the verticals is by means of a scale line. Simply extend the bottom horizontal reference line (it doesn't matter if it is to right or left); take distance AB and measure it from point 2 until it cuts the horizontal line.
Any measurement now made on AB can also be placed on the scale line, and drawing horizontal lines from these points back to

the vertical 2/3 provides an accurately scaled-down measure accounting for perspective diminishment.

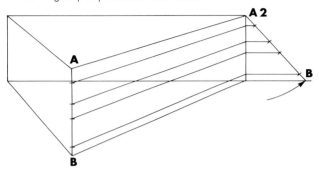

Corresponding measurements are achieved on the vertical 1/4 by projecting the horizontals from the scale line.

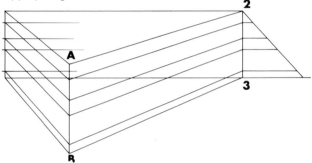

The grid can be set up above or below the horizon line to give a variety of viewpoints. Using this construction method, you know that these are correct vanishing lines, in that if they were extended they would meet at two vanishing points on the horizon line.

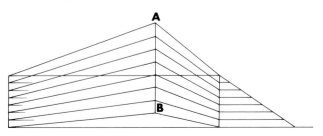

A RIGHT-ANGLED GRID

The next problem is to create vanishing lines that go back at 90°, or right angles, to each other. This is the angle normally chosen when drawing grids.

Imagine a circle seen in plan view. A right angle like the corner of a box can be drawn from its centre point (a quarter-circle segment).

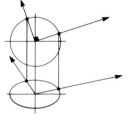

When the circle is seen in perspective it becomes an ellipse. If you draw the circle and ellipse one above the other, the points where the right angled lines hit the circumference of the circle can be dropped onto the curves of the ellipse. Now draw vanishing lines from the centre of the ellipse through those points: these lines are receding at right angles to each other.

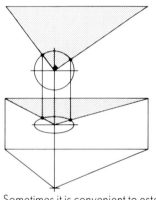

A horizontal reference line can be drawn in, a second vanishing line added lower down to establish the perspective, and the fourth vanishing line found by joining the second horizontal reference line to the vertical from the top perspective line.

Sometimes it is convenient to establish the perspective by means of the ratio of ellipses chosen for the top and bottom of the front vertical measuring line. In this instance the top and bottom ratio ellipses are chosen, the points from the circle (shown in plan as a semicircle) dropped down to each ellipse, and the vanishing lines drawn from these.

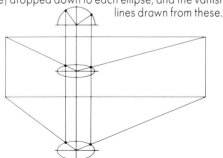

Changing the angle of view

It is easy to fall into the trap of using the same grid with the same angles for a variety of applications, where it is in fact very quick and easy to set up a new grid for each job.

The angle from which you look onto the corner of the box can be changed, as can the ratio of ellipses from shallow to round to give a variety of views and degrees of perspective.

You need not select a view looking down at the subject; setting up a grid above the horizon line is just as easy.

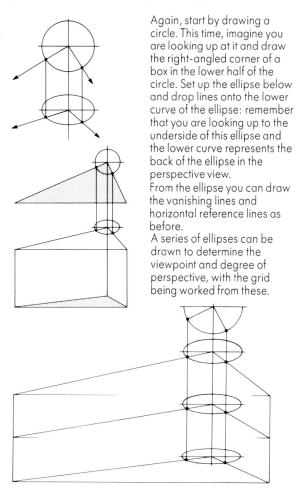

Again, start by drawing a circle. This time, imagine you are looking up at it and draw the right-angled corner of a box in the lower half of the circle. Set up the ellipse below and drop lines onto the lower curve of the ellipse: remember that you are looking up to the underside of this ellipse and the lower curve represents the back of the ellipse in the perspective view.

From the ellipse you can draw the vanishing lines and horizontal reference lines as before.

A series of ellipses can be drawn to determine the viewpoint and degree of perspective, with the grid being worked from these.

Vertical ellipses

To create ellipses on the vertical planes, which will be needed to help measure and to draw circular shapes, you need to follow a few simple rules.

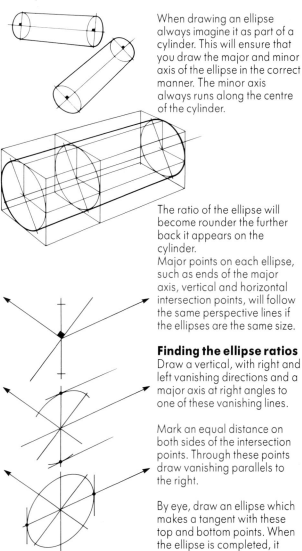

When drawing an ellipse always imagine it as part of a cylinder. This will ensure that you draw the major and minor axis of the ellipse in the correct manner. The minor axis always runs along the centre of the cylinder.

The ratio of the ellipse will become rounder the further back it appears on the cylinder.

Major points on each ellipse, such as ends of the major axis, vertical and horizontal intersection points, will follow the same perspective lines if the ellipses are the same size.

Finding the ellipse ratios

Draw a vertical, with right and left vanishing directions and a major axis at right angles to one of these vanishing lines.

Mark an equal distance on both sides of the intersection points. Through these points draw vanishing parallels to the right.

By eye, draw an ellipse which makes a tangent with these top and bottom points. When the ellipse is completed, it

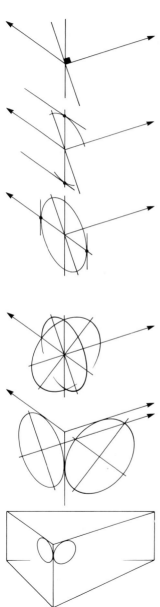

should also make a tangent with verticals where it passes through the right vanishing line. It may take some trial and error before the correct ellipse ratio is found.

The mirror image process is followed to find the ellipse ratio on a plane receding to the left. The vertical is drawn, with right and left vanishing lines and the axis of the ellipse.
Equally spaced points are made on the vertical and tangent curves to the left vanishing lines drawn at these points. The completed ellipse must also make tangents to verticals where it passes through the original left vanishing line.

When the two correct ratios are established, they appear on the central datum point. Because they are geometric ellipses with the centre point in the true centre, it would not be correct to use them in this position to create a perspective grid.

They should be slid down their respective planes to fit into the corners of the two vanishing planes. When placing them here, remember that the minor axis should follow a correct right or left vanishing direction.

The ellipses will appear thus on the perspective planes.

Squaring the grid

With the ellipses in position in the top corner of each plane, you can then draw a perspective square around each one. This enables you to use the diagonals of these squares to create a squared grid.

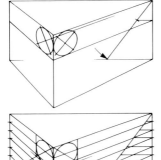

Measure down the front vertical (the datum line) the approximate vertical height of the ellipse. Use this same measurement on the scale line to draw vanishing lines which make tangents with the bottom edges of the ellipses. Draw vertical tangents on the outer edges of the ellipses to give you the square.

You can now draw a diagonal through the corner of each square and project it to the bottom edge of the grid.

Draw units of a convenient size down the datum line, scale these using the scale line and draw in all the vanishing parallels. Where these lines cut the diagonal you can draw verticals to construct the squared grid. These squares will become smaller the further back they go, due to the vanishing parallels becoming closer as they recede.

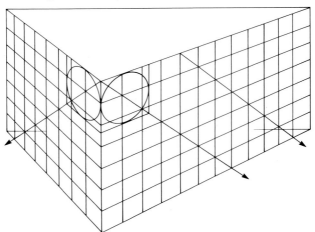

To extend the grid back, draw additional diagonal lines through the squares already drawn. Where these new diagonals hit the vanishing lines, new verticals can be drawn. This can be continued either backward or forward of the datum line.

When drawing a shape on the grid, some edges of the object can be plotted straight onto the two vertical planes.
Where an edge locating the back of the object has to be drawn, it is still necessary to follow the set vanishing directions. Place a long ruler against the back corner of the object as defined on the vertical plane, and by eye make sure that it follows the direction of the vanishing lines, even though it may not coincide with one exactly.

In order to draw some parts of an object, it may be necessary to extend the grid upward to give a good guide for drawing the vanishing lines.

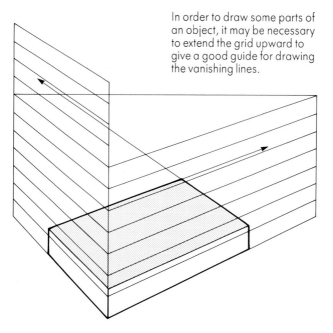

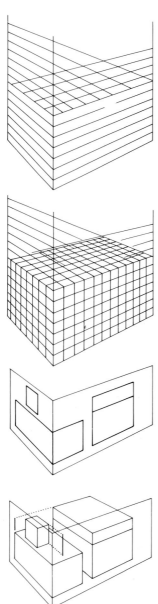

The horizontal plane

Extend the grid of vanishing lines upward and then project them forward until they reach the top edge of the squared vertical planes.

Using these lines as a guide, the squares already drawn on the two side planes can be taken across the top surface of the grid, forming a squared horizontal plane which together with the two vertical planes forms a boxed-in grid.

Drawing the object

When constructing an object on this type of grid, first outline main components on the two vertical planes.

When these measurements are projected within the box, you can start to build up the three-dimensional features of your chosen object.

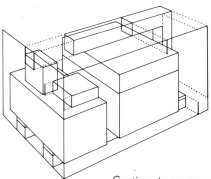

Continue to measure along
the two vertical planes and
project in from both sides.
Square end blocks (prisms)
are constructed to contain
cylindrical forms.

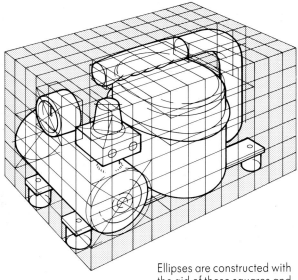

Ellipses are constructed with
the aid of these squares and
the whole picture can be
gradually built up.

THREE-POINT PERSPECTIVE GRID

In three-point perspective, verticals also become vanishing lines, giving a more complex and sometimes more realistic three-dimensional impression. Some objects require a three-point perspective because of their scale, some benefit from it to enhance the finished view.

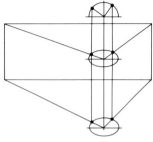

One method of drawing a three-point grid is to start by constructing a two-point with ellipses drawn at the top and bottom of a datum line.

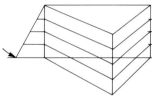

Next by means of a scale line, add a series of vanishing parallels.

Then draw two horizontals just clear of the grid lines. The amount of three-point vanish can now be constructed and you can judge this by eye, according to your image of the object you wish to draw. Put in a vertical vanishing line at the outer edge of your grid.

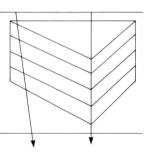

Now divide up the two horizontal lines across the area between the datum line and the perspective vertical line, using the same number of divisions at top and bottom. These units can be stepped off on the other side of the datum line as well.
When all these points are joined you have a grid incorporating perspective verticals that if extended would converge at a single vanishing point.

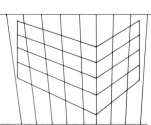

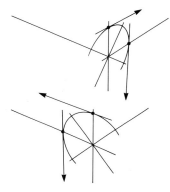

When finding the ellipses for the two vertical planes, the ellipse still has to make a tangent with a right or left vanishing line at the top and bottom. The tangents at the sides are made with the new perspective verticals.

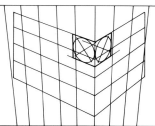

Again these two ellipses are positioned in the near corners of the grid in order to draw perspective squares around them.

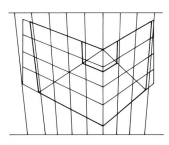

Draw diagonals through these squares and extend them to the bottom edge of the right and left vanishing lines.
Two larger perspective squares can now be defined, using the various vanishing lines as guidelines.

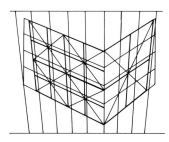

These large squares should be subdivided by means of diagonals, vanishing lines and more diagonals, until a comprehensive squared grid is built up on the vertical planes.

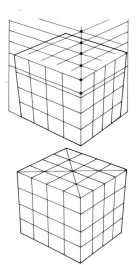

Continue the lines of the two-point grid up the sides and project them forward of the datum line to create a grid of guidelines across the top of the box.

On this horizontal plane, project the squares from the top edges of the two vertical planes. Draw the diagonals on this top plane to check that all the lines are accurately drawn.
This is a three-point perspective cube with a squared grid on the three visible surfaces.

These surfaces can be extended in a number of directions by projecting diagonals through the squared grid. This can be done to suit the shape of a particular object to be drawn. The limiting factor is the cone of vision, as the drawing will appear very distorted if the grid is extended too far.

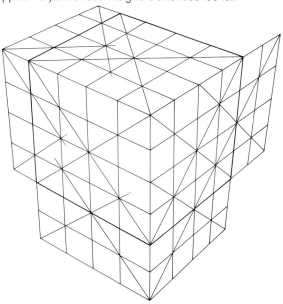

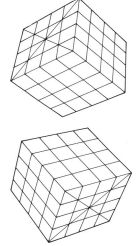

Once an accurate three-point grid has been drawn, it can be used in a variety of positions. It can be tilted, or spun around so that you obtain a view from below. There is a great number of possible viewpoints.

Also, if the grid is drawn on tracing paper or drafting film, this can be flipped over so you see the grid from the other side, doubling the available viewpoints obtainable from one grid.

Images are built up as before, by drawing on the outer surfaces of the box and projecting lines inward. Where these lines intersect, key points for building up the image are located. If you have flat views or orthographics of the object, it can be helpful to draw a squared grid on those views to the same scale as your perspective grid.

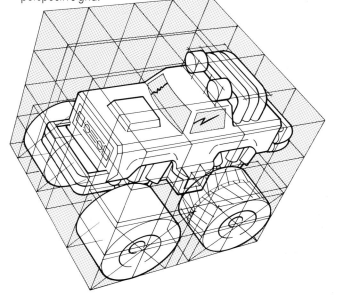

CONSTRUCTION ON A VERTICAL AXIS

Other types of grids are used where the object is symmetrical about a centre axis, as with circular or cylindrical components 'threaded' on a centre line.

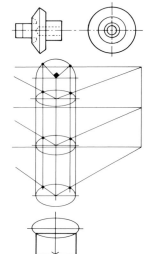

These flat views show parts of a gear. A perspective construction of the gear can be made on a vertical datum line.

Using a semicircle as your plan, set out a right angle for the two vanishing directions. Ellipses can be set off down the vertical datum: these become progressively rounder as your viewpoint causes you to look down the object.

The flat view of the object is plotted on the datum line to a suitable (scale.

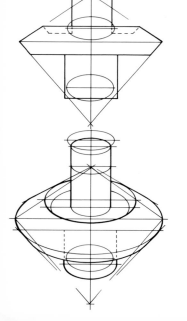

Ellipses are drawn through the various corner points to give the three-dimensional illusion. Parts that go behind others are drawn lightly or left out altogether.

Elements of the construction
spread evenly around a circle
(the splines and gears) are
positioned with the aid of
semicircles. These are drawn
just clear of the object, and for
each one the diameter is
equal to the major axis of the
ellipse to be divided.

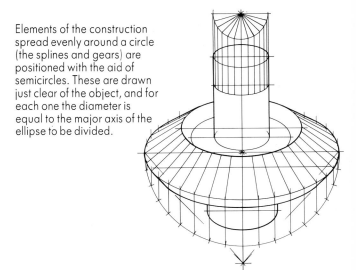

The semicircle is divided by means of an adjustable set-square
(triangle), proportional dividers or protractor to give the
required number of divisions.
The points on the semicircles are then projected onto their
matching ellipses to give the correct stepping.
Points appear closer together toward the major axis ends of the
ellipses, and wider apart near the minor axis ends.

The vanishing lines are used to
show a section of the gearing.
The lines are brought forward
until they hit the front edge of
each ellipse. These points can

be joined to make a right-
angled section seen in
perspective.

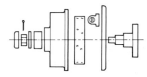

CONSTRUCTION ON A HORIZONTAL AXIS

Objects constructed on a horizontal centre axis can also be drawn on a two-point grid, with the centre line being one of the vanishing directions.

Set up a two-point grid of perspective lines with the horizontal ellipse placed at the centre of the datum line. Establish the ellipse ratios for the two vertical planes as previously, by tangents at the top and sides.

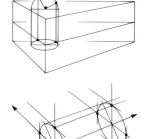

You will need to find the ratios of ellipses along the proposed axis of the object. Find a number at various points along the axis using the same method as before. Their position to start with is not critical, but when a number have been found, you should be able to space them along the axis so that they form even steps in ratio.

One ellipse at right angles to those on the axis is drawn at the centre position on the measuring plane. A perspective square is drawn around this to allow a diagonal measuring line to be located. This is extended both forward and backward of the datum line.

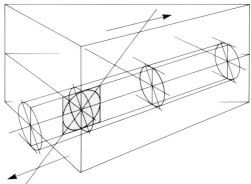

The sections of the shapes of the object are drawn along the vanishing axis.

The height of each piece is first drawn on the datum line and then drawn forward or backward.

The distance back is drawn up from the centre datum point, projected back on a vanishing line until it hits the measuring diagonal, and then dropped to the centre line.

The distance forward is drawn down from the centre datum, projected forward until it hits the diagonal, then taken up to the centre line.

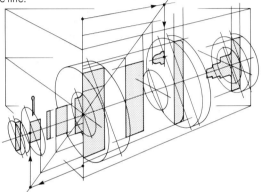

When the sections are established along the vanishing axis, ellipses can be drawn through the corners of each shape to build the three-dimensional image.

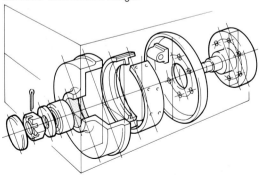

Again parts that go behind others are not drawn in, and the vanishing lines can also be used to make right-angled sections of the object.

Most points can be measured accurately in this way, with very little needing to be guessed.

INTERSECTING AXES

Most objects are more than simple geometrical shapes on a common centre line, and will require a more complete measuring construction. The front and side views of the object to be drawn can be first overlaid with a squared grid, the squares being any convenient size.

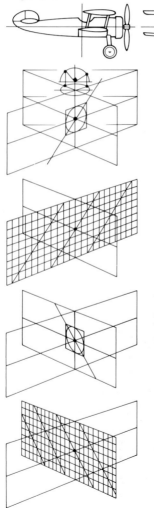

A two-point grid of right and left vanishing planes is constructed in the normal manner.

The ellipse in plane is found in one vanishing direction. A perspective square is formed around it and the diagonal to that square drawn and extended.

Units are measured up the datum line and vanishing lines drawn forward and back. Where they hit the diagonal, verticals are drawn to give squared units extending forward and backward from the datum line.

The same construction is used on the other vanishing plane to give squared units of diminishing size on both right and left planes.

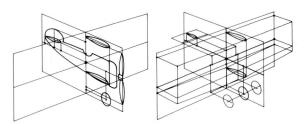

The section of the object can be drawn on one side by taking measurements up the datum line and projecting these back with vanishing lines. They coincide with measurements taken back on the vertical planes, using the squares to count the distance, and projecting up from various key points.

To find points in space that do not lie on the two main vertical planes, it is best first to draw the distances of these points on the two principal centre lines. Then project the points up or down, forward or backward, depending where the selected point lies in relation to these centre lines.
Additional measurements are made on these two planes and projected until you build up a criss-crossed network of lines, and the object is drawn through the points of intersection.

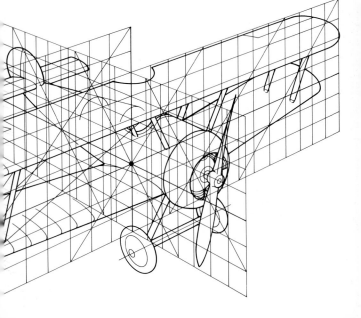

SHADOWS AND REFLECTIONS

These elements give greater authenticity to your perspective drawing, emphasizing depth and volume.

CAST SHADOWS FROM THE SUN

A shadow is formed when an object obscures the light source. When that light source is the sun, and because of its immense distance from us, the rays of light are considered to travel parallel. This being the case, the shadow of a shape with parallel sides will itself be parallel. If the shadow has parallel sides, then it will follow the normal rules of perspective and appear to vanish at infinity on the horizon line.

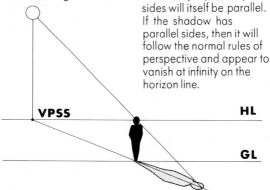

In normal perspective, if the sun is in front of the spectator, the shadow is cast on the ground plane and this shadow will vanish to a point on the horizon line vertically below the sun, known as the vanishing point sun's shadows (VPSS).

With the sun behind the spectator, the shadow is cast forward and its vanishing point (VPSS) is on the horizon line. The vanishing point sun's rays (VPSR) is located directly below the VPSS.

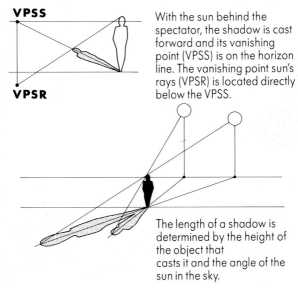

The length of a shadow is determined by the height of the object that casts it and the angle of the sun in the sky.

The angle of the sun

When introducing shadows from the sun into a drawing one may have to consider time of day and the differing lengths of shadows this will cause. Also, the time of year relating to summer or winter equinox is important, as the sun's height varies enormously depending on season.

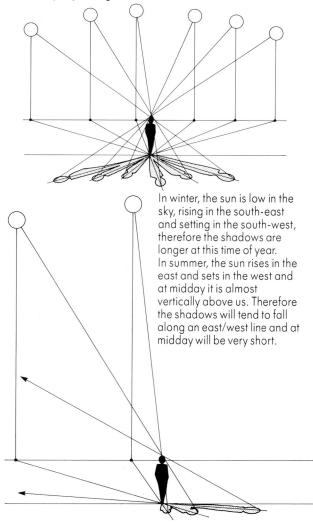

In winter, the sun is low in the sky, rising in the south-east and setting in the south-west, therefore the shadows are longer at this time of year.
In summer, the sun rises in the east and sets in the west and at midday it is almost vertically above us. Therefore the shadows will tend to fall along an east/west line and at midday will be very short.

Position of the sun

When constructing a measured perspective drawing, two angles are required to find the position of the sun.

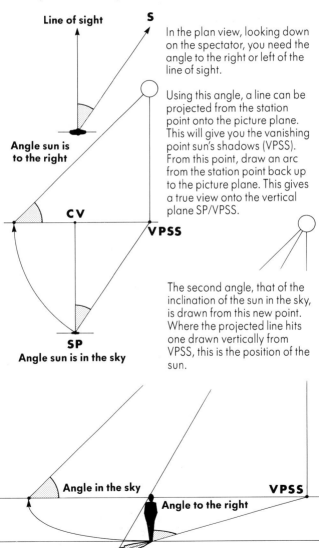

Line of sight

S

In the plan view, looking down on the spectator, you need the angle to the right or left of the line of sight.

Angle sun is to the right

Using this angle, a line can be projected from the station point onto the picture plane. This will give you the vanishing point sun's shadows (VPSS). From this point, draw an arc from the station point back up to the picture plane. This gives a true view onto the vertical plane SP/VPSS.

CV

VPSS

SP
Angle sun is in the sky

The second angle, that of the inclination of the sun in the sky, is drawn from this new point. Where the projected line hits one drawn vertically from VPSS, this is the position of the sun.

Angle in the sky

VPSS

Angle to the right

Plotting the shadow

When constructing shadows cast from an object, you will need to know where the vanishing points for the object are, as well as the two vanishing points of sun's rays and sun's shadows.

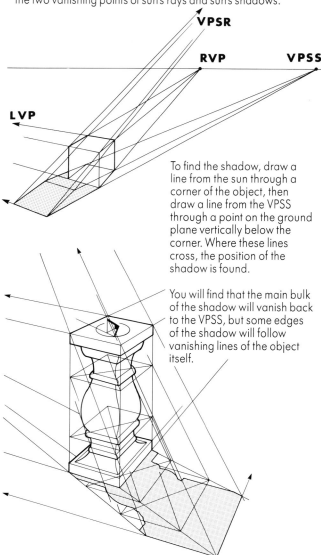

VPSR

RVP **VPSS**

LVP

To find the shadow, draw a line from the sun through a corner of the object, then draw a line from the VPSS through a point on the ground plane vertically below the corner. Where these lines cross, the position of the shadow is found.

You will find that the main bulk of the shadow will vanish back to the VPSS, but some edges of the shadow will follow vanishing lines of the object itself.

Shadows cast forward of the spectator

When the sun is behind the spectator you will need two angles to find the position of the sun.

Line of sight

suns rays

Angle sun is to the left behind

In the plan view looking down on the spectator, you need the angle the sun makes in relation to the line of sight.

Using this angle, a line is drawn up to the picture plane to give the vanishing point sun's shadows. From this point, draw an arc from the station point back up to the picture plane.

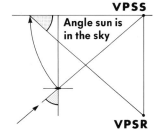

VPSS

Angle sun is in the sky

VPSR

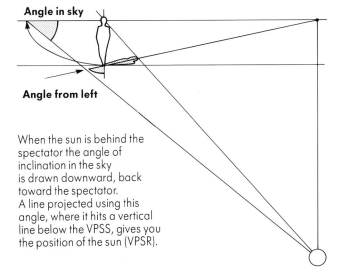

Angle in sky

Angle from left

When the sun is behind the spectator the angle of inclination in the sky is drawn downward, back toward the spectator.
A line projected using this angle, where it hits a vertical line below the VPSS, gives you the position of the sun (VPSR).

You need to know the two vanishing points of the object to be drawn as well as the vanishing points for sun's shadows and sun's rays.

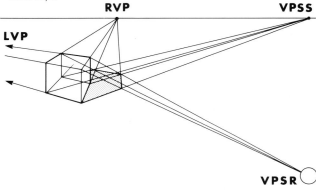

Lines are drawn from the sun through corners of the object. Then lines are drawn to the VPSS from points on the ground plane vertically below the corners. Where these lines cross, the position of the shadow is found.

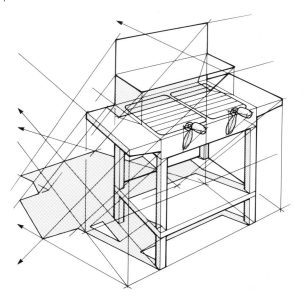

When drawing shadows, you first select the point to cast a shadow from, you then draw a line through that point to the VPSR. You must then find a second point vertically below the first on the ground plane or other horizontal plane. From this second point a line is drawn back to the VPSS. Where the lines cross, you have the points of the shadow.
Some edges of the shadow will vanish to the vanishing points of the object.

Shadow projections
Shadows can be used effectively on various types of projections as well as in perspectives. If you have the plan and elevation of a building, simple shadows can be added to the plan to help give a three-dimensional impression.

In the elevation, parallel lines are drawn from the sun through points on the building onto the ground. These points are projected onto the plan view. In the plan view, shadow lines are drawn from the sun's position and where these cross the lines from the elevation, the points for the shadows are found.

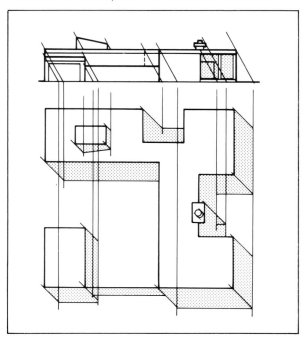

In this one-point perspective the sun is behind and slightly left of the spectator, You will see that some shadow lines vanish back to the vanishing point sun's shadows and others go back to the centre of vision.

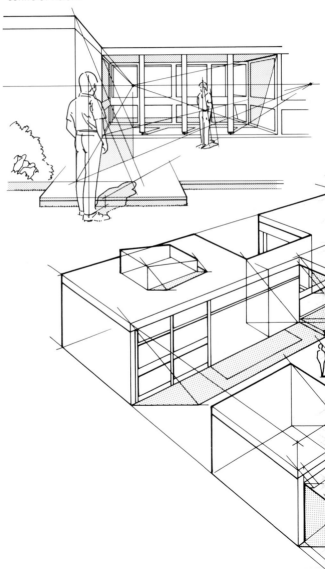

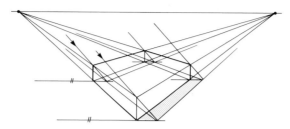

With a two-point perspective, the sun can be positioned to the right or left of the spectator and not in front or behind. This will result in parallel lines for the sun's rays and sun's shadows.

This is an easy and effective way to add shadow to architecture as you don't need to plot the vanishing point for the sun's shadow or find the position of the sun.

With an adjustable set-square (triangle) set to the angle of the sun in the sky, you can simply draw through various

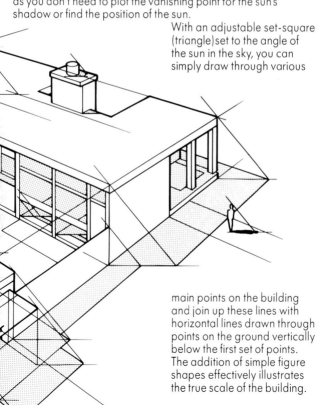

main points on the building and join up these lines with horizontal lines drawn through points on the ground vertically below the first set of points. The addition of simple figure shapes effectively illustrates the true scale of the building.

SHADOWS FROM ARTIFICIAL LIGHT SOURCES

Shadows cast from an artificial light source differ from those cast by sunlight in one main respect. As the light source is near in comparison to the sun, the light rays are not parallel but are shown as radiating from a given point.

Shadows of parallel-sided vertical objects are not themselves parallel so do not vanish to points at infinity on the horizon line. Shadow lines vanish to points vertically below the artificial light source.

In construction you need to know the vanishing points of the object, the source of light, and a point on the ground vertically below that light.

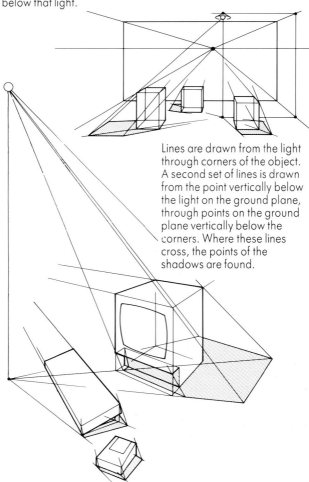

Lines are drawn from the light through corners of the object. A second set of lines is drawn from the point vertically below the light on the ground plane, through points on the ground plane vertically below the corners. Where these lines cross, the points of the shadows are found.

The main rules of constructing the shadows are: first draw lines from the light source through the points to be cast as shadows; next, find new points vertically below the first ones on the ground plane or other horizontal plane (the tabletop), and draw lines from a point vertically below the light source through these second points.

Note that there is one vanishing point for the shadows on the ground plane and one on the tabletop.

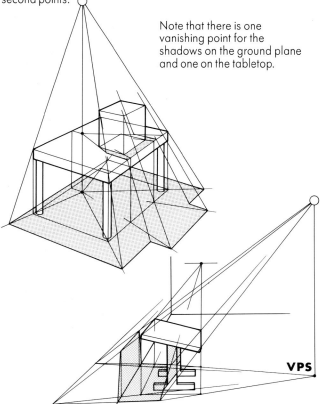

Where the shadow falls onto a vertical plane, first construct a shadow as if the vertical plane were not there.
Draw a vertical between the top near edge of the object and the point on the ground vertically below it. Where the line from the vanishing point shadows is projected and hits the corner of the wall, draw a new vertical. This represents the original vertical line projected onto the wall. The top of the projected vertical is the corner of the shadow on the wall.

Cylindrical forms

With a cylinder standing on the ground, draw the position of the light and then a position vertically below it on the ground plane, the vanishing point shadows (VPS). From this VPS, draw lines through the base ellipse of the cylinder. Where the lines cut the ellipse, project up to the top ellipse. These top points are where you should project lines from the light back onto the ground. Where the corresponding lines cross, the outline of the shadow is found.

VPS

RVP

When the shadow is being cast from a separate object onto a cylinder, first find the light source, then the point on the ground vertically below the light source at the level of the shape casting the shadow, the raised vanishing point (RVP).

Draw lines from the RVP through the object back onto the cylinder. Drop lines down from these. Then draw lines through the same points on the object to hit the lines on the cylinder.

To cast a shadow inside a hollow cylinder, find the light, the vanishing point shadows and the raised vanishing point. Draw lines from the RVP across the inner ellipse at the top of the cylinder, and drop them down the inside curve. Draw lines of light through the points on the nearside of the top ellipse to hit the vertical lines on the other side.

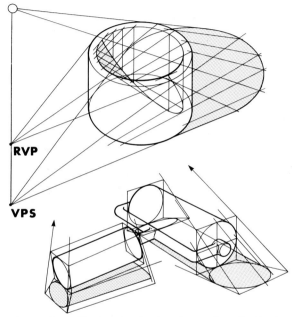

RVP

VPS

Another method of finding the shadow shape of a cylindrical object is to enclose the cylinder in a simple square prism and project the shadow formed by that prism onto the ground plane.

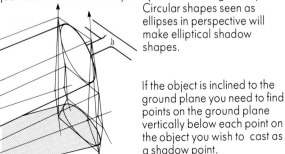

Circular shapes seen as ellipses in perspective will make elliptical shadow shapes.

If the object is inclined to the ground plane you need to find points on the ground plane vertically below each point on the object you wish to cast as a shadow point.

Inclined planes

Shadows falling onto inclined planes use the same lines from a light source and from the vanishing point shadows. Where the shadow lines hit the intersection of ground plane and inclined plane, lines are drawn up the side of the inclined plane following its angle of inclination to meet the lines from the light source.

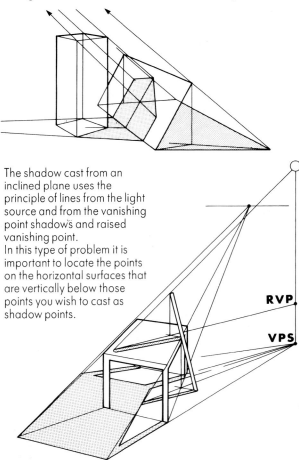

The shadow cast from an inclined plane uses the principle of lines from the light source and from the vanishing point shadows and raised vanishing point.
In this type of problem it is important to locate the points on the horizontal surfaces that are vertically below those points you wish to cast as shadow points.

RVP

VPS

Curved objects

To plot a shadow cast onto the curved surface of a cylinder, the easiest method is to construct the cylinder in a square prism. In this instance, the vertical shape casts a shadow over the prism that can be projected as rectangular shapes appearing to slice

across the cylinder at an angle. Curves can now be constructed within these rectangular slices.
Note that the curves formed are ellipses, but of a different ratio to those at front and back of the cylinder (which are, in fact, circles as the cylinder is drawn in one-point perspective).

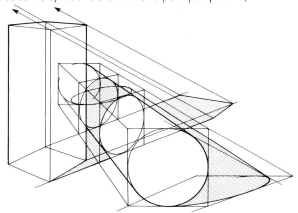

To cast a shadow from a sphere is a tricky constructional problem, which is more an academic exercise than a practical means of forming a realistic shadow.

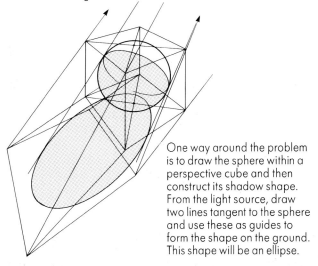

One way around the problem is to draw the sphere within a perspective cube and then construct its shadow shape. From the light source, draw two lines tangent to the sphere and use these as guides to form the shape on the ground. This shape will be an ellipse.

REFLECTIONS

Reflections can add a useful different dimension to a drawing; they are relatively easy to visualize and construct. Apart from actual mirror images, reflections are commonly seen on horizontal surfaces such as water or a polished tabletop, but there is a wide range of effects that can give great complexity and visual interest to a perspective drawing.

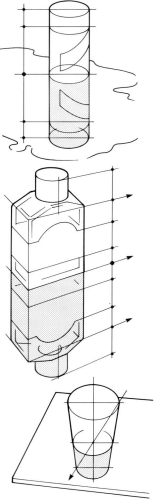

Horizontal reflective surfaces

With a simple cylinder standing on a reflective surface, the reflection lies vertically below the object and appears the same size. This construction is easily made by drawing horizontal lines through main parts and measuring equal distances down a vertical line passing below the reflecting surface.

With this object in angular perspective, again lines can be drawn through main points and linked to a vertical height line, these measurements being then marked out below the reflecting surface.

When looking down on a cylinder, the distance the reflection appears below the mirrored surface can be constructed with the aid of a diagonal taken from the end of one ellipse through a centre point to cut the vanishing line on the other side.

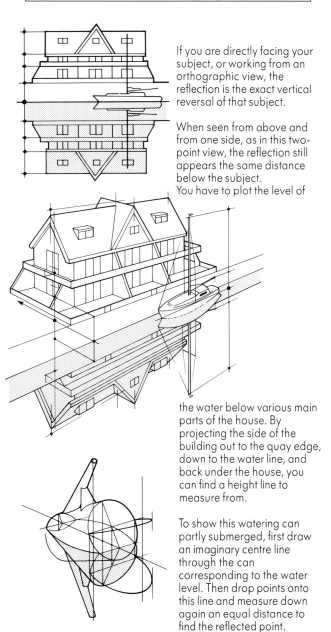

If you are directly facing your subject, or working from an orthographic view, the reflection is the exact vertical reversal of that subject.

When seen from above and from one side, as in this two-point view, the reflection still appears the same distance below the subject.
You have to plot the level of the water below various main parts of the house. By projecting the side of the building out to the quay edge, down to the water line, and back under the house, you can find a height line to measure from.

To show this watering can partly submerged, first draw an imaginary centre line through the can corresponding to the water level. Then drop points onto this line and measure down again an equal distance to find the reflected point.

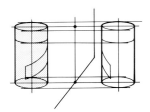

Vertical reflective surfaces

With vertical reflective surfaces (mirrors) the reflection of an object appears the same distance into the mirror as the distance of the object in front of the mirror.

In this one-point drawing of a room with a large mirror on one wall, the mirror plane vanishes back to the centre of vision. Horizontal measuring lines can be drawn from the object into the mirror. Distances can be taken from the room interior and, using the intersection of the mirror plane and ground plane as a datum line, measured back into the mirror.

Even though the mirror does not touch the ground, in a construction it is still the intersection of the mirror plane and ground plane that is used as the datum line.

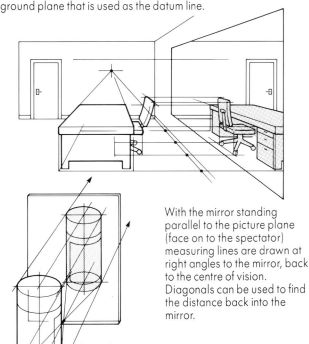

With the mirror standing parallel to the picture plane (face on to the spectator) measuring lines are drawn at right angles to the mirror, back to the centre of vision. Diagonals can be used to find the distance back into the mirror.

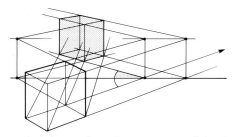

With an angled object reflected in a mirror parallel to the picture plane, the vanishing lines of the object can also be projected back to the mirror to help form the construction of the reflection. Seen in plan view, to obtain the correct spatial arrangement lines are drawn from the object to the mirror, and the same distance back into the mirror. To achieve the angled mirror image, lines from the object are extended until they touch the mirror, and are then reflected back into the mirror using the same angle. The angle of incidence is equal to the angle of reflection.

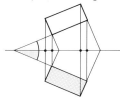

Using the above knowledge, it is possible to plot the shape of a reflection with some accuracy. In this three-point drawing, the vanishing lines of the object are extended until they touch the mirror, and are then reflected back using the opposite angles. Where these lines cross, the reflection is formed.

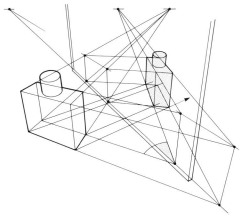

Inclined reflective surfaces

Even if the reflective surface is inclined, the same laws of reflection apply: 1. The reflected object appears the same distance behind the mirror as the actual object is in front of it. 2. The angle of reflection of a line on the mirror is equal to the angle of incidence of that line.

In the one-point view, lines are taken across the ground plane until they meet the intersection of the two planes, where they are then reflected off at the opposite angle. Also lines are projected at right angles to the mirror and are projected an equal distance back into the mirror from the points where they touch the surface.

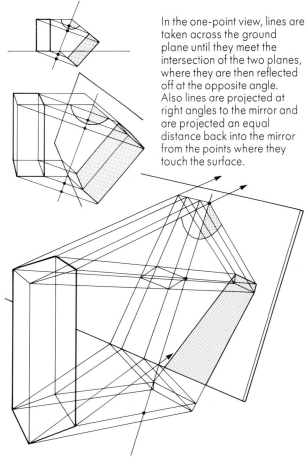

With the object turned and the mirror turned, it is still possible to construct the reflection by the same methods. Keep in mind that you are working in perspective and make all the construction lines follow the correct perspective back to imaginary vanishing points.

Multiple reflections

A combination of three mirrors, one on each of the three principal planes, can be used to great effect in some perspective images.

In the mirrored ceiling and wall arrangement shown, the light fitting will be reflected an equal distance back into the ceiling. The fitting and its reflection will also be reflected in the two side walls, and one of these reflections will in turn be reflected again in one of the side walls.

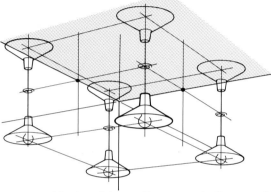

The same combination of direct reflections and reflections of reflections will occur with the three-mirror arrangement shown of a wine glass on a horizontal plane reflected in adjacent vertical planes.

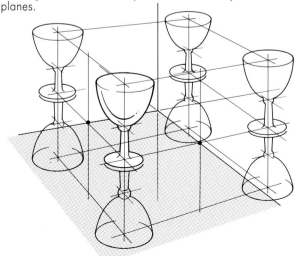

ACKNOWLEDGEMENTS

Series editor: Judy Martin
Design and art direction: Nigel Osborne
Design assistant: Peter Serjeant
Artwork: Mark Way